Reality Check
James Peebles Jr
San Diego, Ca.

This is a second series of books of poetry I wrote. It was written when I was alone with mental illness with no one. Except me and my iPad. I became an author by accident with no idea this would turn out to be a book. Of all things like poetry. I first became introduced to poetry by wanting to talk to someone besides praying to God. I didn't want to journal. That would be too flat for me. Just writing to myself.

I needed some method to put my thoughts down in a novel way such as to answer my inquiries about life's issues. In a way that helped my feelings and addressed what I was dealing with. I became a poet. Not the kind that one wins a Nobel Prize. Someone average, like most. One that could attempt to solve my concerns on paper or in my case my iPad. Dealing with abstract subjects only poetry could answer.

It started to work and now I made books dealing with my life with mental illness. You don't have to be mentally ill to understand my writings. It's universal to all. I would be thankful for you to take the time to read this book. And try to understand what it's like for me to deal with this life with mental illness. I hope you see my work as art.

Family

Families are great
Families are fine
When you're alone
They're like sweet wine

Don't get me wrong
Or to suppose
When you're in need
They'll give you cloths

Love is a word
Not just a verb
When you're in trouble
Family's superb

I know that I love them
Not just in words
When there is no one
They're on, no blurs

Birds are my favorite
Loving so sweet
Knowing your family
Can make me tweet

Forgiveness is something
I hope that I learn
If you're the victim
Better discern

I have a brother
Which I love lots
Then when I think
I'm right on top

I have two sisters
Who love me more
If I could keep it
They'd win the score

I've had some trouble
Families aware
Where did I go to?
My loves who care

This may seem funny
Although that it's true
When you've got family
Things aren't so blue

Bad times or good times
Family is here
When there are hard times
Buddy beware

This might sound corny
Though it is not
When you've got family
You've got what you've got

I don't want to change things
As are they are
When you got family
They're never too far

If I could send them
All of my love

They've made my life full
Like a sweet dove

When we're in Heaven
God will ask why?
How did you make it?
Because my family did try

Truth

Orange is gray
Purple's white
We decide when to fight
Where's the delusion?

People tell me to my face
Lies that burn
Lies that hate
Where's the truth?

I'm losing my sanity
When people deceive
I have little proof
Just that I grieve

Having no defense
Only my strange memory
Makes me question
My holy sanity

Being known as crazy
Makes people think
Is this guy lazy?
Or does he stink?

People can gaslight me

This I can tell
I'm in a position
For yet to yell

Don't get me wrong
I'm not a saint
When someone hurts me
I kinda faint

Being a bully
I've met my share
When you're on Mark Street
Buddy beware

What have I learned?
Sounds like a lot
When you're the victim
Better just trot

Lying is hurtful
Speaking the truth
Which will you call for?
In life's phone booth?

Embers

Embers embers
Burning bright
I'm the one
That's so uptight

Housing, neighbors
They're all here
You can't see
This thing called fear

Discrimination
Civil rights
Don't confuse them
They're out of sight

I can't tell you
In too few lines
It's complicated
To put down in rhymes

I get angry
A lot it seems
Dire straits
It's stares, it gleams

The angers leaving
The thoughts have stayed
I want to forget
This poem I made

Concentrating
On all I have
Means little now
This poem's salve

Life

Life is real funny
Life is so strange
What can you learn?
What can I change?

Sometime it hurts
Sometime it's fun
Who can you talk to?

When life is done?

God knows the answers
Some though do not
Life's a big puzzle
Don't let it rot

What am I after?
Is that I cry
Calling forever
Deep to the sky

People can hurt me
Right from the start
Will I be happy?
Or is this an art?

When I was born
I had no clue
With all this thinking
What will I do?

Life can be exciting
Or even a bore
Come let me tell you
Life's so much more

The sun now has set
The stars out tonight
Why do I wonder?
Why do I fight?

Life's not a gamble
Sometimes it is
My last reminder
What can I give?

Sometimes I'm stupid

Sometimes I'm smart
This life will give you
Something of art

I want to be righteous
I don't want to sin
Living on Main Street
Where have I've been?

I want my life hopeful
Nothing to waste
Life in a cradle
Now there's no trace

Life lived in private
Life lived in peace
Where is my mother?
When will this cease?

Clovers are pretty
Roses are too
Not finding kindness
Makes me real blue

Life can be fruitful
Nothing is lost
My life's a big mystery
Paying this cost

Life will be over
Someday unknown
What will I show for?
Being alone?

Life's greatest secret
Will it be found?
Looking behind me?
Making no sound

Stars out in heaven
Rocks in a mine
Will I discover?
When it's my time?

Birds are out singing
Mountains are high
Will I find freedom?
Or will I cry?

When do I go home?
Heaven or Hell?
God's keeping silent
I wish he would tell

Now for the color
Beauty's so great
Life is worth living
Don't be too late

I'm really not that old
In some ways I'm young
When I am laughing
You'll know that I've sung

Now that I've found peace
Inside my heart
When I am dying
Then life will start

Now that I'm ending
What's more to say?
Just that I hope for
More than I pray

If I make Heaven
I'll know that I've made

God's holy ocean
Riding his wave

Betrayal

Betrayal is rough
Betrayal is hard
Who can you trust?
Me a retard?

Life can be cruel
Live can be sweet
When you're betrayed
You're like dead meat

Then there are friends
Some kind of neat
When you're betrayed
Stand on your feet

People are kind
Some though are not
Someone with problems
Can make you rot

What can I say?
When people hurt?
Someone is watching
Behind some old dirt

What someone says
In certain times
Can make a difference
Like in these rhymes

I need an editor
Maybe a ref
To keep my sanity
When nothing's left

I'm really hurting
Bring some relief
Betrayal is something
Don't want to keep

Where are my friends today?
Everyone's gone
When you're alone
What just went wrong?

This listening to griping
Isn't much fun
Betrayal is something
That hurts like a ton

What have you learned now?
Within this space?
People hurt others
In any old place

You're mine now

Little child, you're mine now
The cuffs went on my wrist
The cold dark cell welcomed me to stay
Not just that day, but forever
I stood naked spitting at the officer
Only to wake on a cement floor
My life ended only to begin

The judge said two months

At the state mental hospital
I was born now to Hell
They give me colored pills
None but to deaden my spirit
The shower room was small with the young and old
My dignity was lost, along with my mind

Where is God?
I later found out
He whispered in my ear
Waiting for you here

The days passed by like years
Only all of a sudden they said you can go home, now
Home? I have no home
Just a bed in the dining room, of an apartment
No, a new home, only never to return to the familiar
I was lost in a world I never left

I went back to college
To gain some credibility
I graduated with honors
Only my name was tarnished
I was branded for life

My doctor said I needed love
In, Oh, so many words
Then he told me how
Abortion was decided
For my empty child

The hospitals were many
As I tried to end it six times
Never getting it right again
To fight another day

Will this be my last day?
Tomorrow, I'll never know

Or will I go home?
To be with my empty child?

---

Who can I yell at?

Who can I yell at?
All through these years?
People and places
The past brings me tears

Most don't understand
All I've been through
The people and places
Turns like a screw

The pressures enormous
Few understand
I get suicidal
A weird wonderland

I'm not saying I'm crazy
Or even nuts
It's hard to put up with
Memories that cuts

I'd like to blow up
All this confusion
Reality can't
It's all an illusion

My anger has lessened
This poem is over
Processing feelings
Is my four leaf clover

Now that I've said this
It's over for now
Better than Xanax
My own private Tao

What have I learned?
Who can I yell at?
It's within these lines
And that's that

If this ever happens again
And I'm in a rut
Poetry can help me
Deep in my gut

I did this for me
No one's around
I self medicated
I'm back on the ground

Not knowing

I don't know how to ask for?
How long will it be?
What will it take me?
How long until I see?

Who am I?
Why do I care?
Something is happening
What do I dare?

A question is useless
An answer is less
What is the help for?

Is this a test?

Justice is useless
Chaos is here
What really matters
Except this is fear

Fairness is noble
Hurting is not
Will I find mercy?
In this here my lot?

Words laced with malice
Taken for love
Who can one trust for?
Peace with a dove?

Who should I look to?
When no one's there?
Right's not the answer
When God is there

Take this as holy
Time who knows when?
If God's not with us
Life seems real slim

Now that I'm going
Lord knows but where
This life's on empty
Hope I don't swear

Sanity

Sanity how sweet the sound

When you have bipolar
The walls do come down
Although I fly tonight
Who knows who's right?

When you are crazy
Then no one cares
Take some more pills, to fill these here tares
Tonight though for dinner, does speak to me
Dish me up something, some sanity

When you write poetry
You're supposed to rhyme
Then when you don't
You're Frankenstein
This poem's mine
Nobody else, if you want order
Go look on a shelf

What can I say, to make me think?
Bipolar and meds, God does this stink
Should I go to sleep? To get some rest?
Now is the time, to pass this test
Fill in this line, for it to fit
Now there's no rules
This poem's lit

How many more words, words do I write?
Some old dumb teacher, might feel uptight
What do they want from me?
This is unknown
To have my sanity
I'd take a throne

When you write about sanity
Some snook, Will plead humanity
Insanity gets an evil eye
When you're bipolar, why?

Now this poem, Gets real exciting
Look both ways, My brain's a sliding
Edgar Allan Poe, had no problem
Right, that's why he sounds, so freaking solemn
This is for me, for not to crow
Edgar Allan, crazy the Poe

Sanity has its place
Tonight there's no trace
What's left to say?
To win at who's pace?

Take your meds today, seems like a plan
Taking my meds tonight, I am what I am
If you hate this poem, please don't blame me
For there's no sanity, Just someone with glee

Changes

Changes before me
Changes behind
If I don't do it
I might go blind

What is the right time?
When is it not?
When I'm with no one
Freaks me a lot

Today is the right time
Yesterday's gone
If I do nothing
I get withdrawn

Teaching is one thing

Learning is too
When you are changing
What can you do?

I know I'm not lazy
Or afraid of big things
Changing is doing
What will it bring?

I'm afraid sometimes
I do not know why
When I am changing
I kinda die

Changing is healthy
Changing is fine
Not liking progress
Makes a bad rhyme

If you like being
Or what you do
Changes does great things
For someone like you

I want to live rightly
Nothing too bad
If I don't change things
I might go mad

What is the bargain?
What does it cost?
Change is the one thing
That makes me the boss

What are you dreaming?
Sounds pretty strange
Changes are coming
Don't be deranged

Sounds like a lot of work
This thing called change
If you don't like it
A horse has a mange

Now I sound stupid
A big funny fool
If nothing changes
Life ain't so cool

Change is real personal
Doing alone
If you want value
Don't be a clone

Now that you know this
Inside and out
When people change you
They have real clout

Clout though is something
Never to give
When someone tells you
Life's worth to live

Critics

Critics are here now
In thoughts and in words
Who will they find?
Me being blind?

When you find fault

Then when you don't
Critics will answer
Some people won't

Who is the expert?
Critics do cry
When you're in Heaven
God will know why

Slamming an artist
Some people do
What are they thinking?
Are they just blue?

Critics cause problems
Some though do not
When you are living
Critics just rot

What do they want?
To make their case?
Critics do nothing
Just to save face

People can argue
People complain
When you're a critic
Life seems insane

Critics are helpful
At certain times
What you won't get
Are sweet Valentines

Critics can harm you
When you relax
Never will tell you
What are the facts

Sometimes they're helpful
When you have doubts
Critics can't tell you
Life's many droughts

What critics do
Is sometimes so kurt
What they don't tell you
Really can hurt

You might think
That critics aren't kind
But let someone tell you
They'll have their time

If I had something
I'd wanted to tell
Critics are people
Not feeling too well

Out in the open
When there is light
Credits do nothing
But yet to fight

Critics do something
Having their place
I hope ones not watching
I need some sweet grace

If I go to Heaven
I hope that I'll say
Critics are helpful
This sunny day

What can I tell you?
I've said quite a lot

Critics can help you
Better or not

Critics are critics
Being like me
Now I'm the critic
What's more to see?

Now that I've said that
I feel really small
Critics are people
Who's left to call?

Critics in life
Do have their place
If you don't think so
God give you grace

Genius

A fool am I to talk about genius
What is a genius?
A thought?
A word?
A work?

Genius is a way of life
We are all geniuses
How do I know?
Look at a retard
How will this show?

How can people measure genius?
In some strange kind of way?
Could it be like an art?
When life falls apart?

Genius is God's expression
With some kind of lesson

Everyone wants to be seen as a genius
Mozart showed it through sounds
Michelangelo showed it through sight
Galileo showed it by discovery
Einstein showed it by theory
We show it by how we live

What makes people of genius great?
Just this
Find truth in something
Find beauty in the ordinary
Find facts in the unknown
Most of all
Find God in everything

What can genius say?
Mostly, I don't know
Then to find out
Are the five senses enough to find genius?
Is there a sixth sense?
Or even a seventh?
Only genius knows

Can a work of art show compassion?
Can thoughts show discernment?
Can life lived well show love?
Only genius will tell
Then when found
One has to know
Genius isn't a person
It's the finger of God touching a mind

Where do I find such a thing?
In a sunset?
Or on the beach?

In the mother's hand of an infant?
No!
In your heart where life begins

Life starts with genius
Just not to take
Masters aren't just geniuses
Anymore then fools aren't just too
Genius is in everybody
To find what we will do

I wish I was a genius
What cost must I pay?
Only tomorrow
Right next to today
When I am praying
Then it will say

Then though in Heaven
God will retort
What were you thinking?
Life's a resort?
No master Jesus
Just that I find
I was a genius
Some of the time

If I hear God's voice
Here on this earth
I'll try to remember
I had a birth
Not there in Heaven
Though many might say
Here in the present
Right here, now, today

God's holy mysteries
If that it's seen

Here in a riddle?
Will it be keen?
Now when it's over
When it is said
What's left to do now?
Just eat some bread?

Genius is thinking
Inside your head
When will you know?
Until you are dead?
What life will wonder?
What have I made?
Genius or nothing?
Inside the grave?

Until this moment
Just that I find
Life's sweetest secret
God's holy time
Genius is right now
Inside your mind
Until tomorrow
Genius will shine

Where do you find genius?
In shape or in time?
What is the asking?
What is to find?

God is in Heaven
Even right here
Genius is something
Never to fear

Now that I've told you
That which I know
Thinking forever

Not much to crow

I might be stupid
Or someone too old
Time though will tell me
Just what I told?

Genius is something
I don't want to miss
Maybe it's getting
My Mom's first born kiss

Anger

Anger a little
Anger a lot
What are you thinking?
Or are you not?

When I am angry
Or feel red hot
Life gets real fuzzy
Like I'm a not

Living a little
Living a lot
Anger is with me
This sorry smock

Take this for granted
Or leave it be
Anger's the answer
Take it from me

When is it over?

When is it not?
Anger will destroy you
Peace though will not

Little minds get angry
Wise men do not
Which would you hang with?
Or will you rot?

This much I'll tell you
If that you care
Winners are losers
With not that much hair

Have you learned something?
Or are you deaf?
Hang around with gripers
Hang at your death

Boring tomorrow

Boring tomorrow
Boring today
Where am I going?
What will I say?

When I am happy
When I am sad
Who do I call for?
Am I just mad?

Life can be simple
Life can be hard
What can I do now?
When I'm on guard?

Timing is simple
Longing is not
Life's got to look ahead
To fill in this slot

Watching for trouble
What should I do?
To keep my head again
Stoping a fool

Each and every morning
Searching for fun
TV is off again
God am I dumb?

Hope's like a friend
Rather sublime
If I don't look again
I'm out of time

Sorry is on again
Footprints unknown
To bring me back again
Before it is shown

Sugar is sweet to me
Honey's the best
Life is too short
To pass this test

Racing this race ahead
Falling so short
Running on empty
Can this be Port?

I'll live my life again
Which way untold
To bring some joy today

Before I'm too old

This is the end
Stop now today
Wait, look, and hope for me
Then it's OK

What Is It?

What is it?
That can't be seen?
It takes contemplation
Do you know what I mean?

Composing music
Or writing down thoughts
It's all quite within me
To find or be lost

Being creative
Thinking no thoughts
That's all that I wanted
To save with no cost

What am I saying?
What do I want?
What is it?
A 6 inch croissant?

What is it?
I cannot yet tell
It's all quite elusive
It's so hard to spell

Can I imagine?
This force that I feel?

This muse might be coming
Fake or for real

How do I know?
Just what it is?
No one can tell me
I can't take a quiz

Beauty and splendor
I wish I could find
These words that I'm using
Are put down in rhymes

This is only a poem
No more or no less
If it turns out a good one
You'll just have to guess

Love

Love is forever
Inside your heart
Who does it call for?
When will it start?

Beauty's with God's love
Here on this earth
Life's a beginning
Love's just a birth

Being with others
Why must this sting?
Love is evolving
Early in spring

People to hope for

How long will this be?
Lovers are calling
Hope one's for me

Roses are blooming
Late summers day
Hope love will find me
Then it's OK

Birds are out singing
Only today
Who do I call for?
No one can say

Love is so far from me
Just that I wish
Someone will find me
Returning a kiss

Touching's so tactile
Holding so close
When will it hit me?
Then shall I boast

Lost close in heaven
Love beacon's call
God is my answer
Feeling so tall

Love is in acting
Timid am I
To find this searching
Never say bye

Men want an answer
Women do too
Love's not in asking
For what we do

Oceans are calling
Streams that are too
Love's not a question
For many not few

This world is big
Water is wet
Love wants to find you
On this I shall bet

When life is over
I hope I shall have
Love's sweetest fragrance
God's holy salve

www.ingramcontent.com/pod-product-compliance
Lightning Source LLC
Chambersburg PA
CBHW020959180526
45163CB00006B/2425